Cute and Whimsical Mermaids

A Color Therapy Coloring Book

By

Kim Jordan Blair

I *would like to Thank Renee Kritzer for coloring the mermaid on the cover of this book*

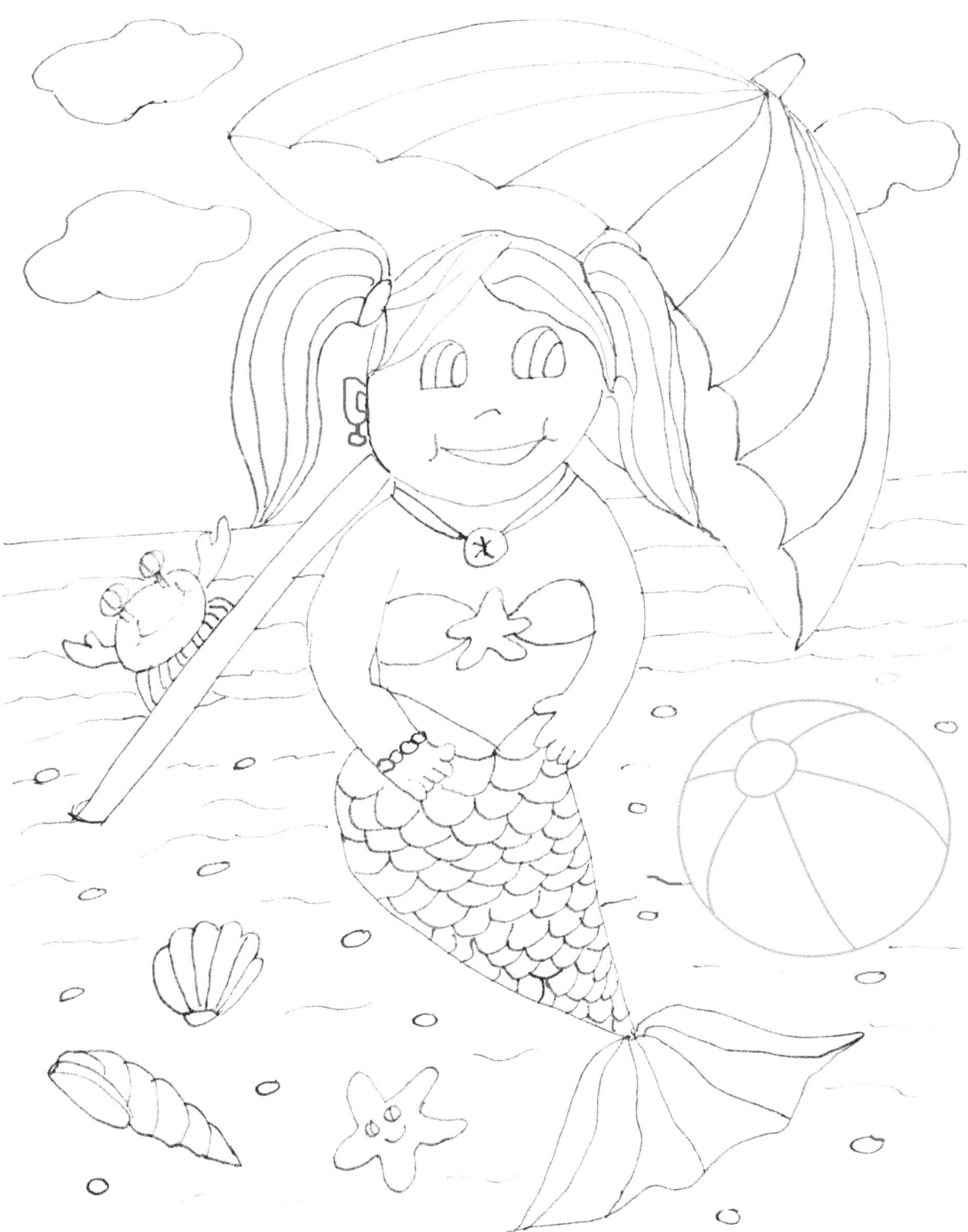

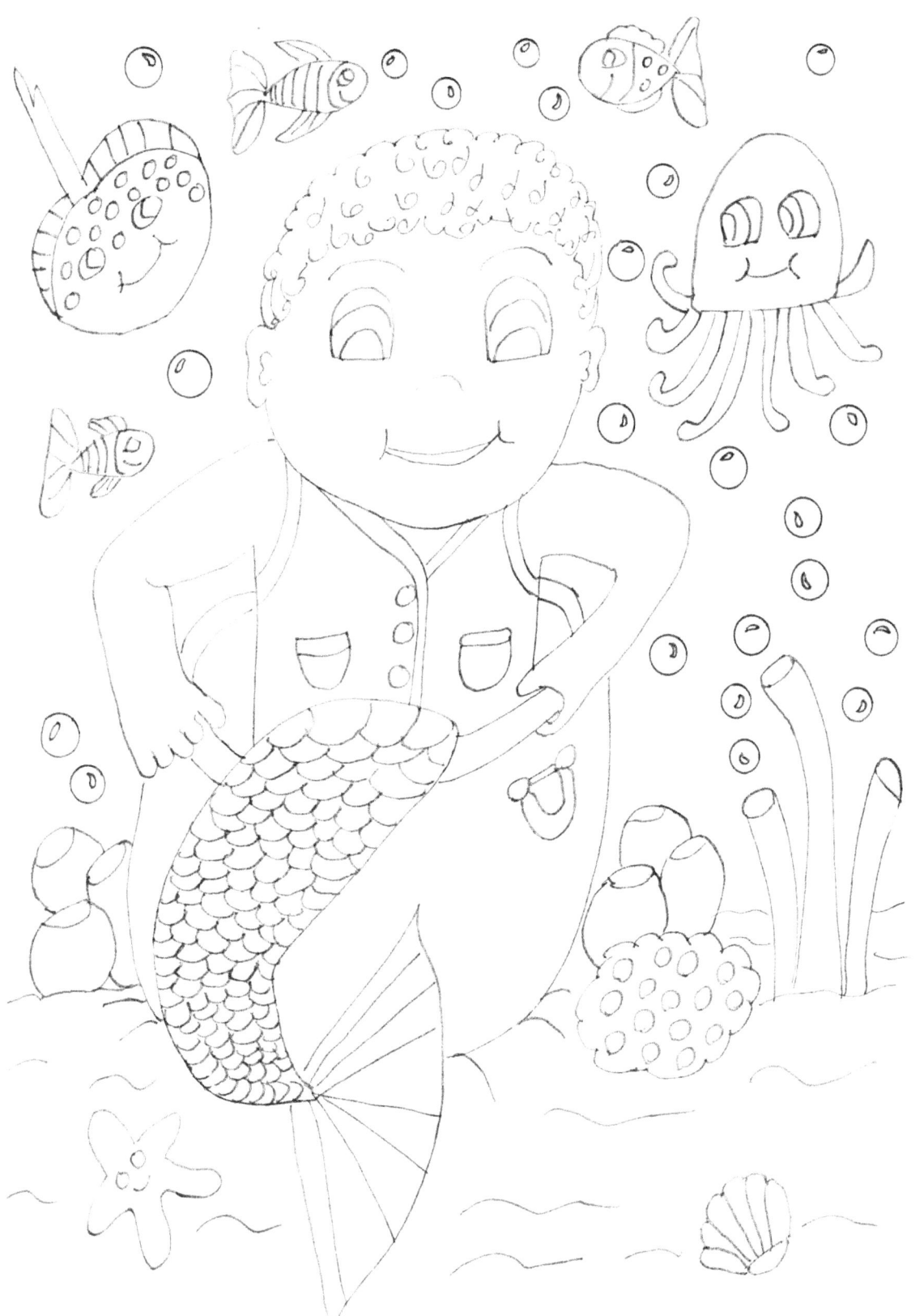

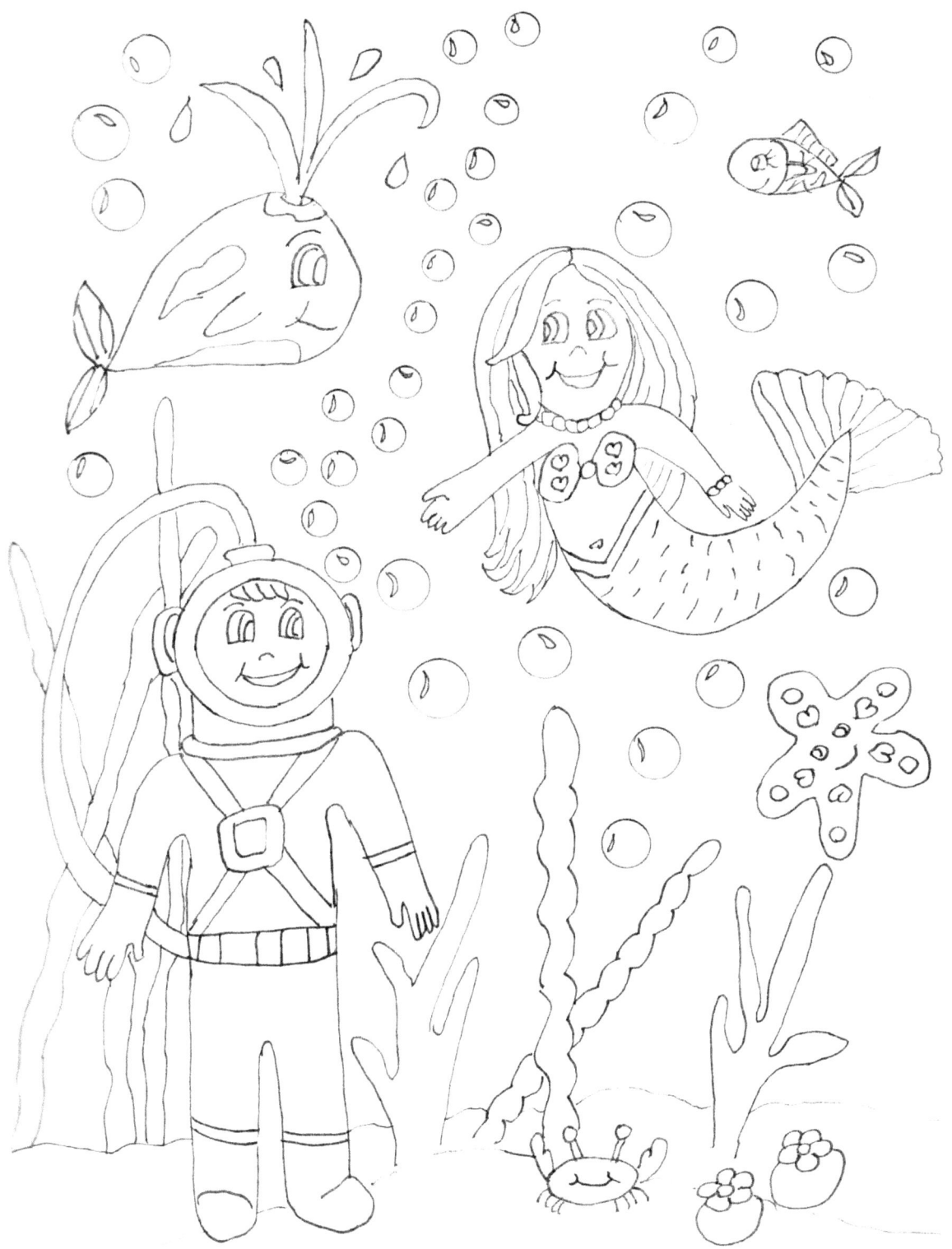

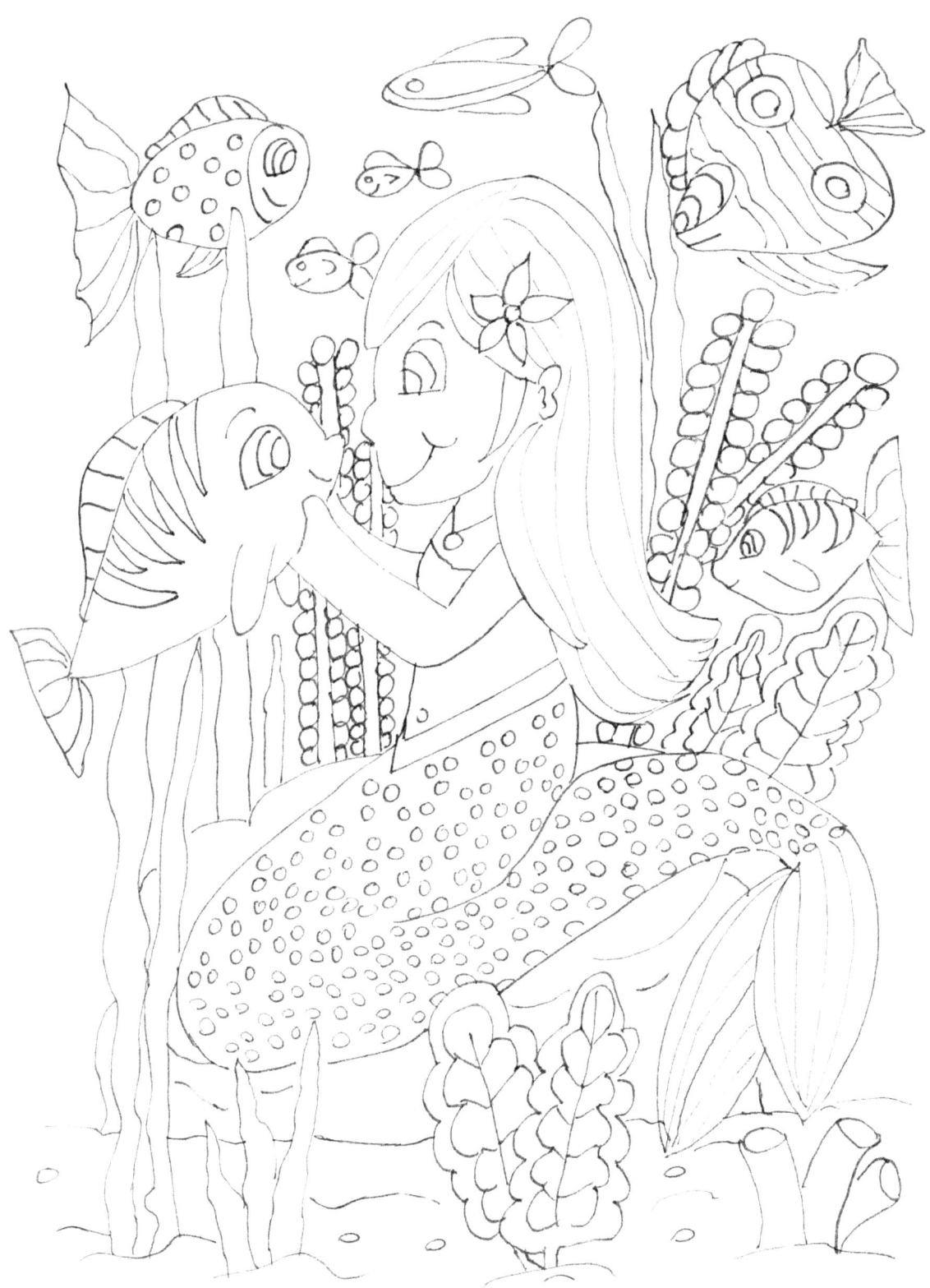

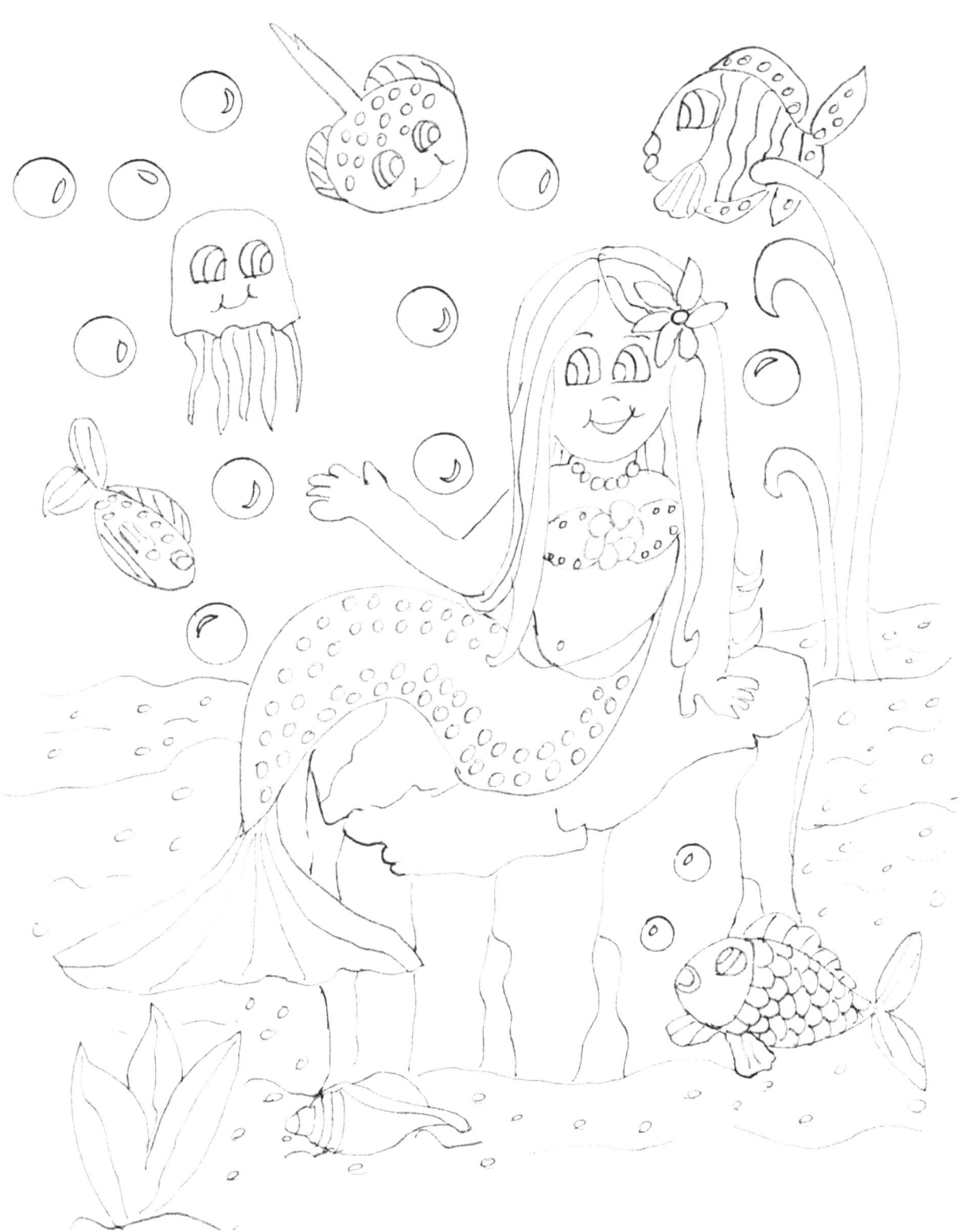

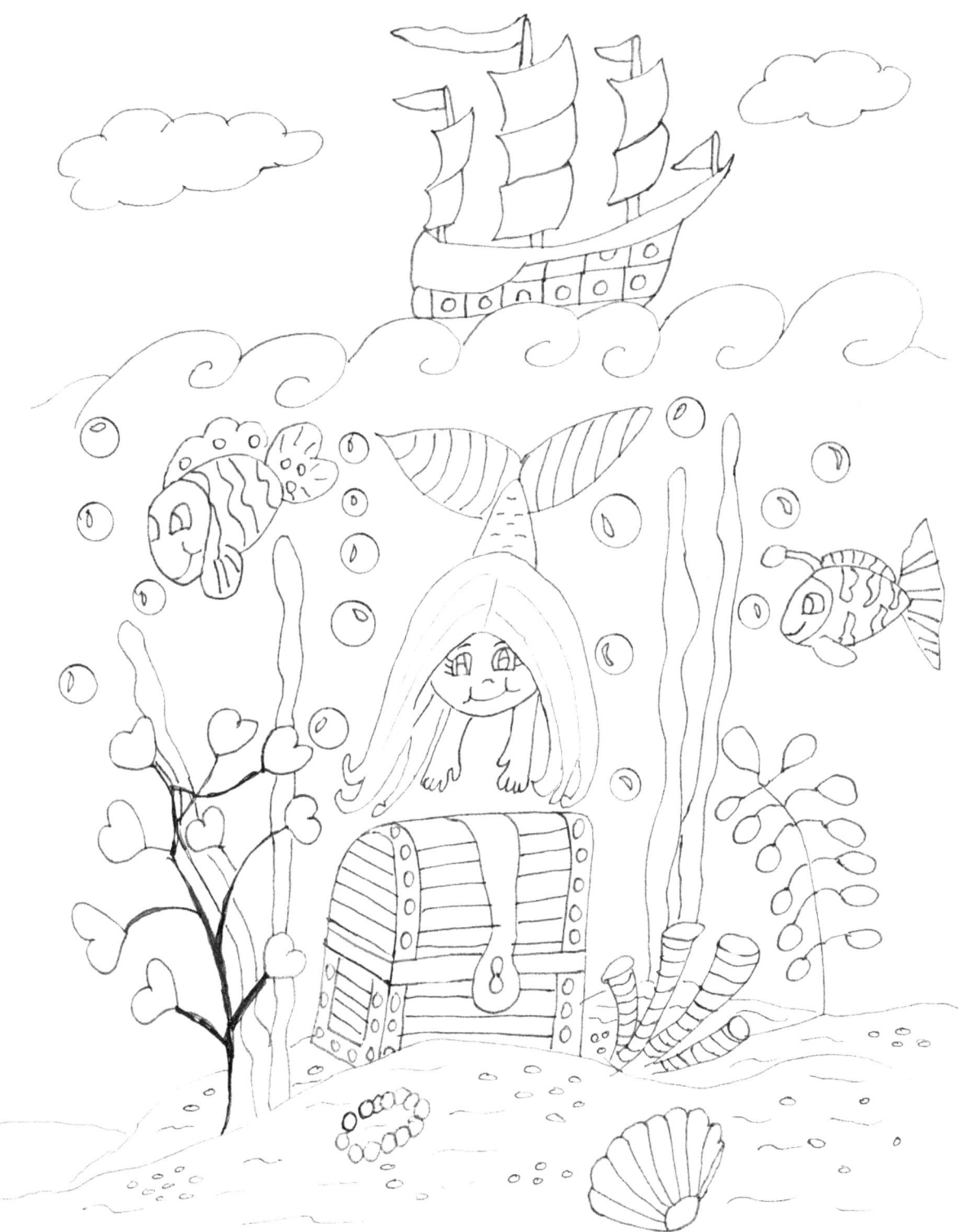

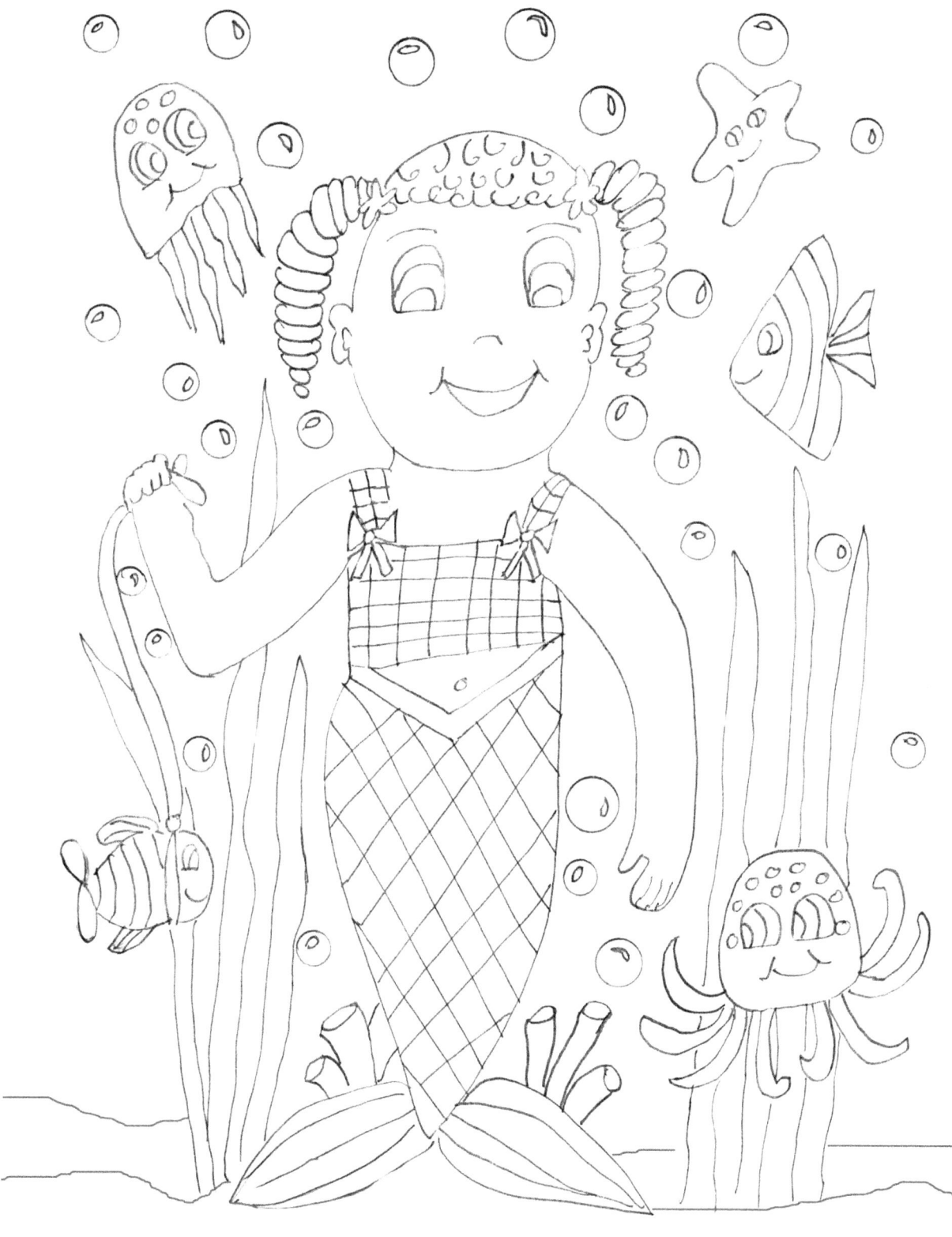

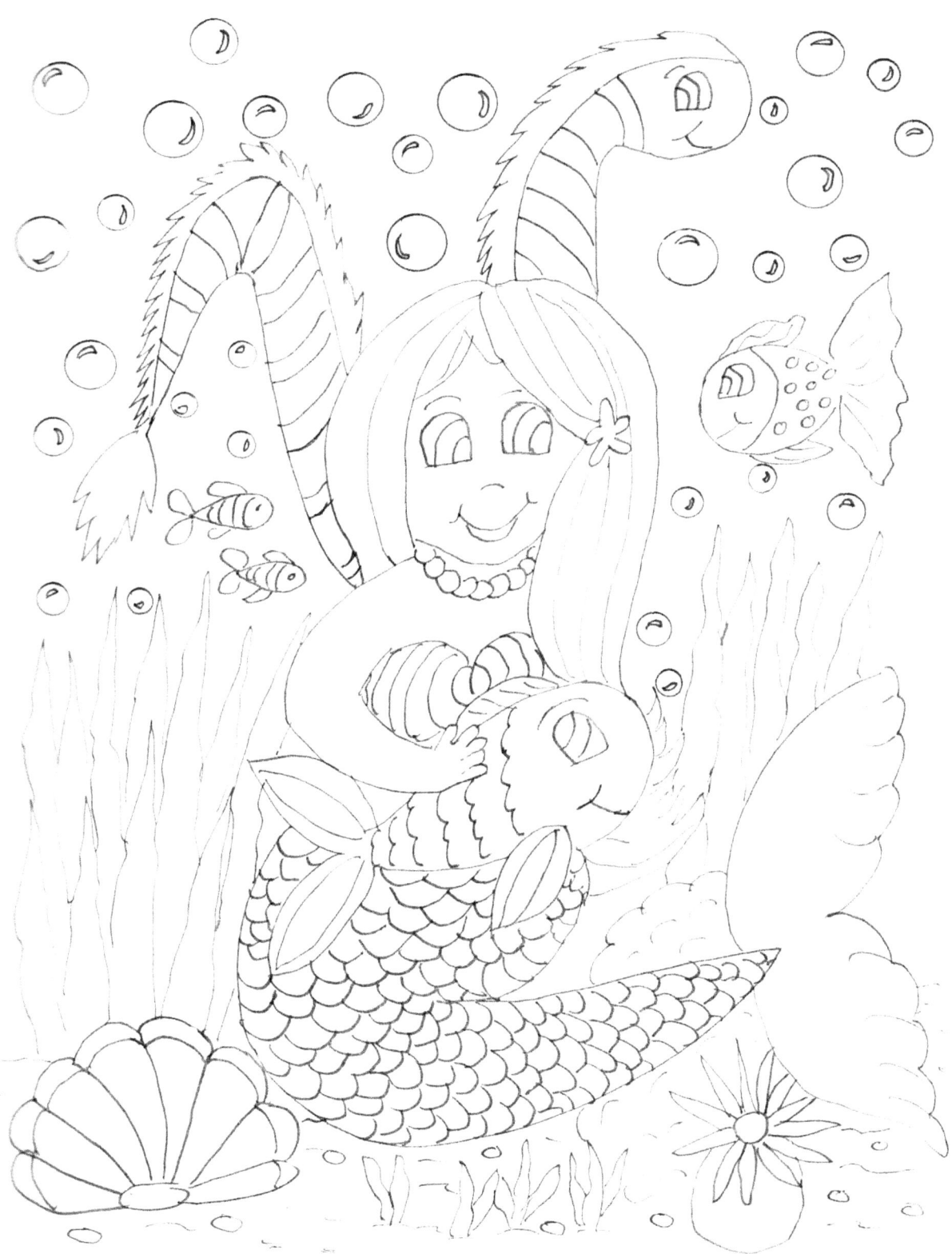

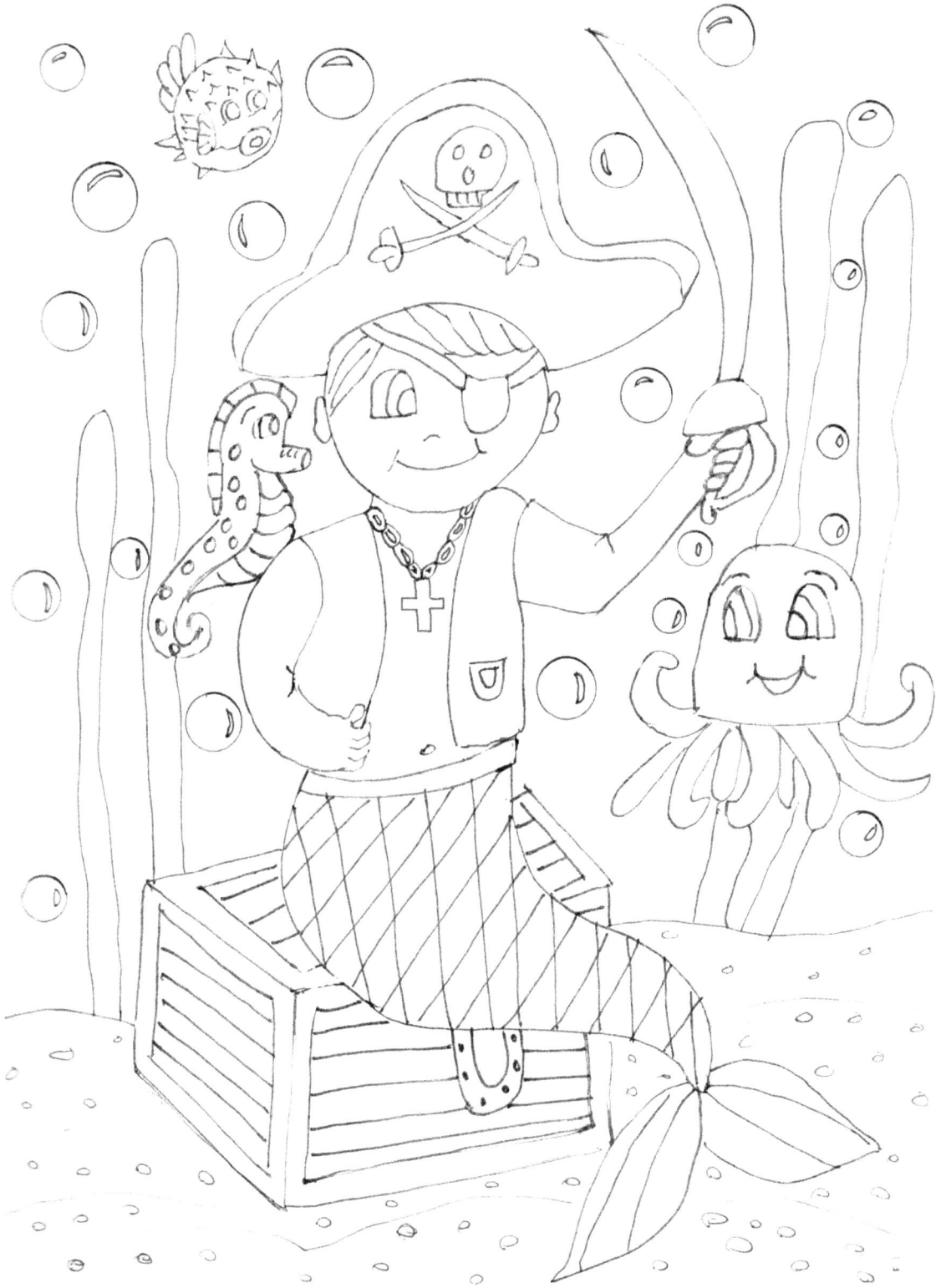

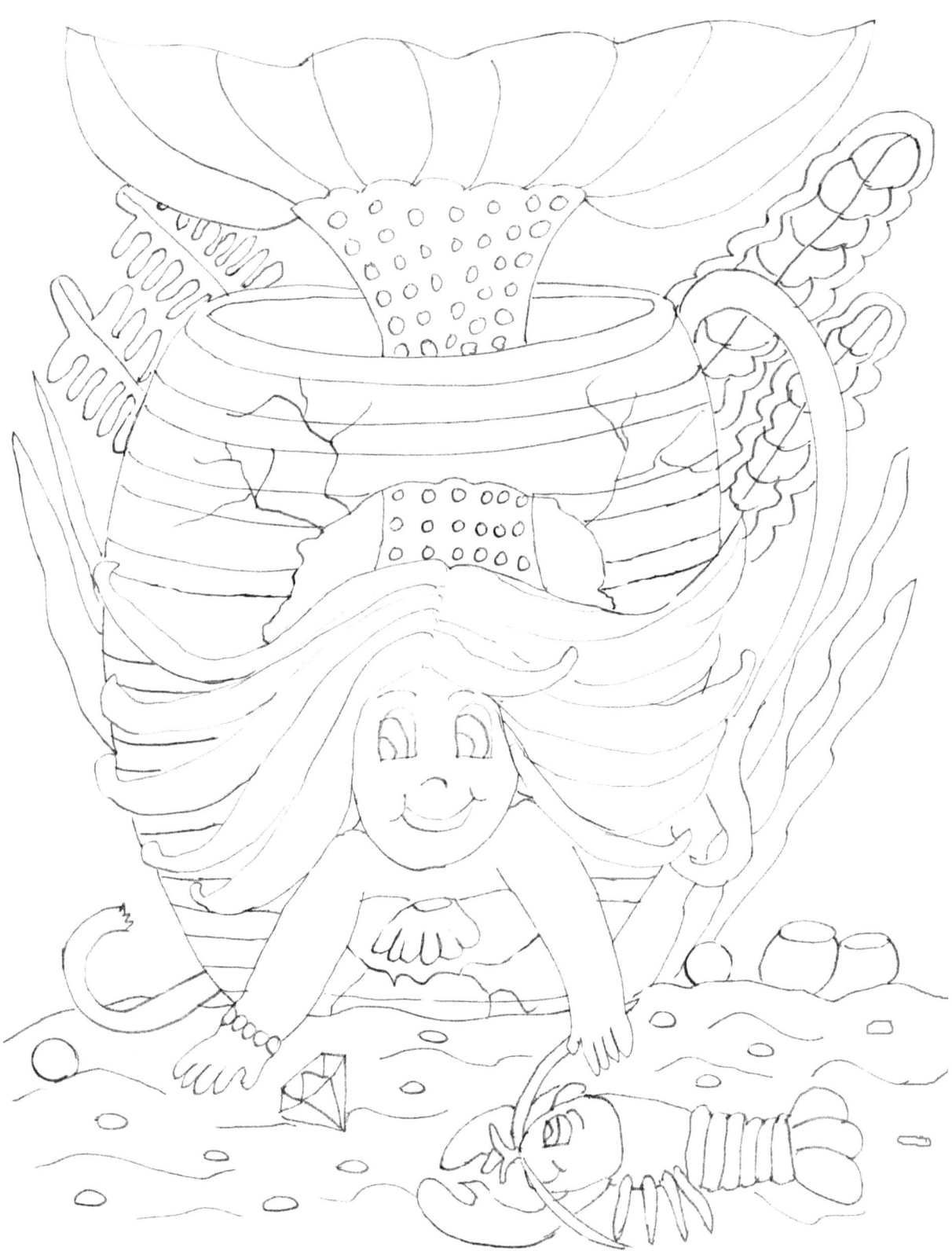

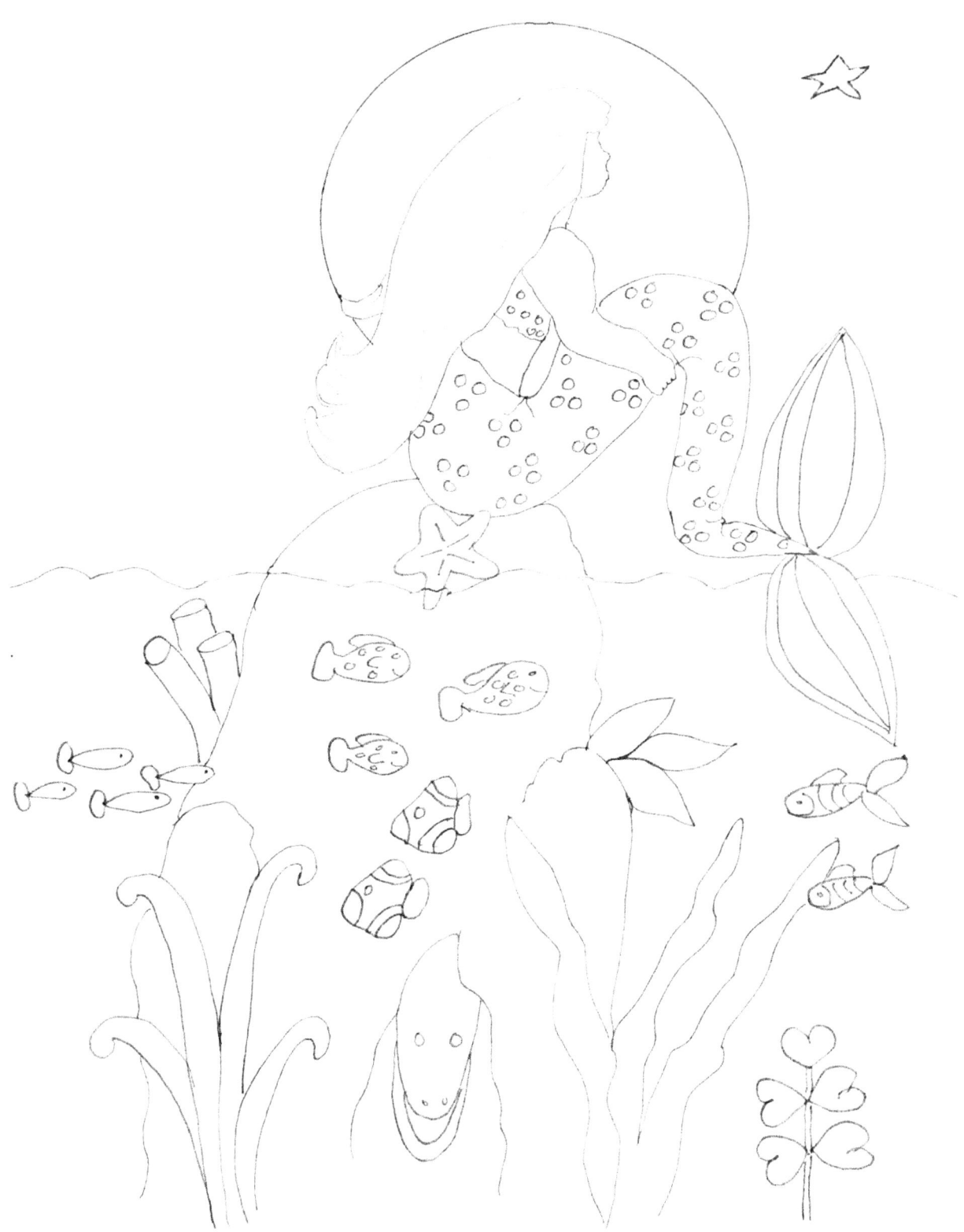

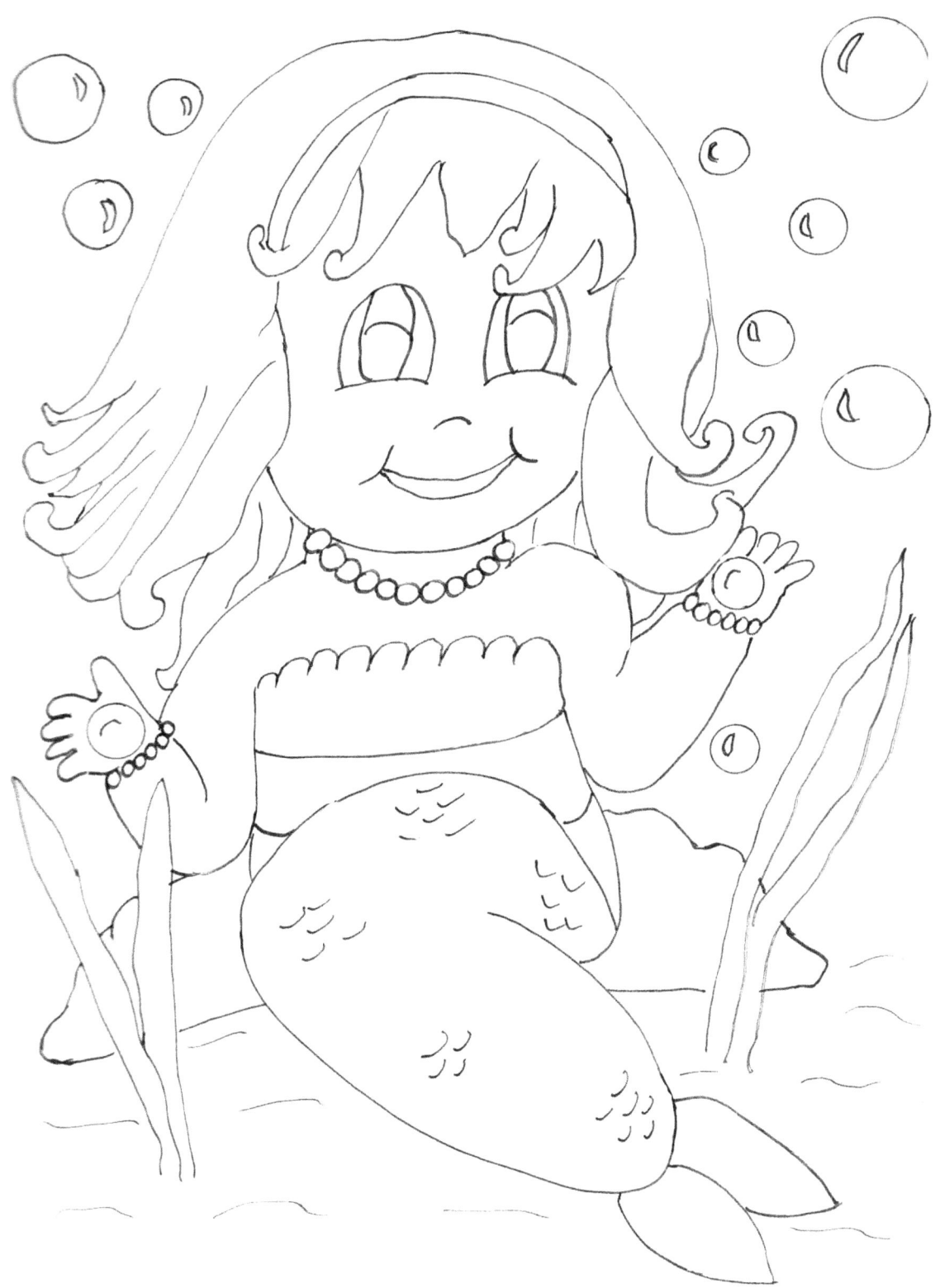

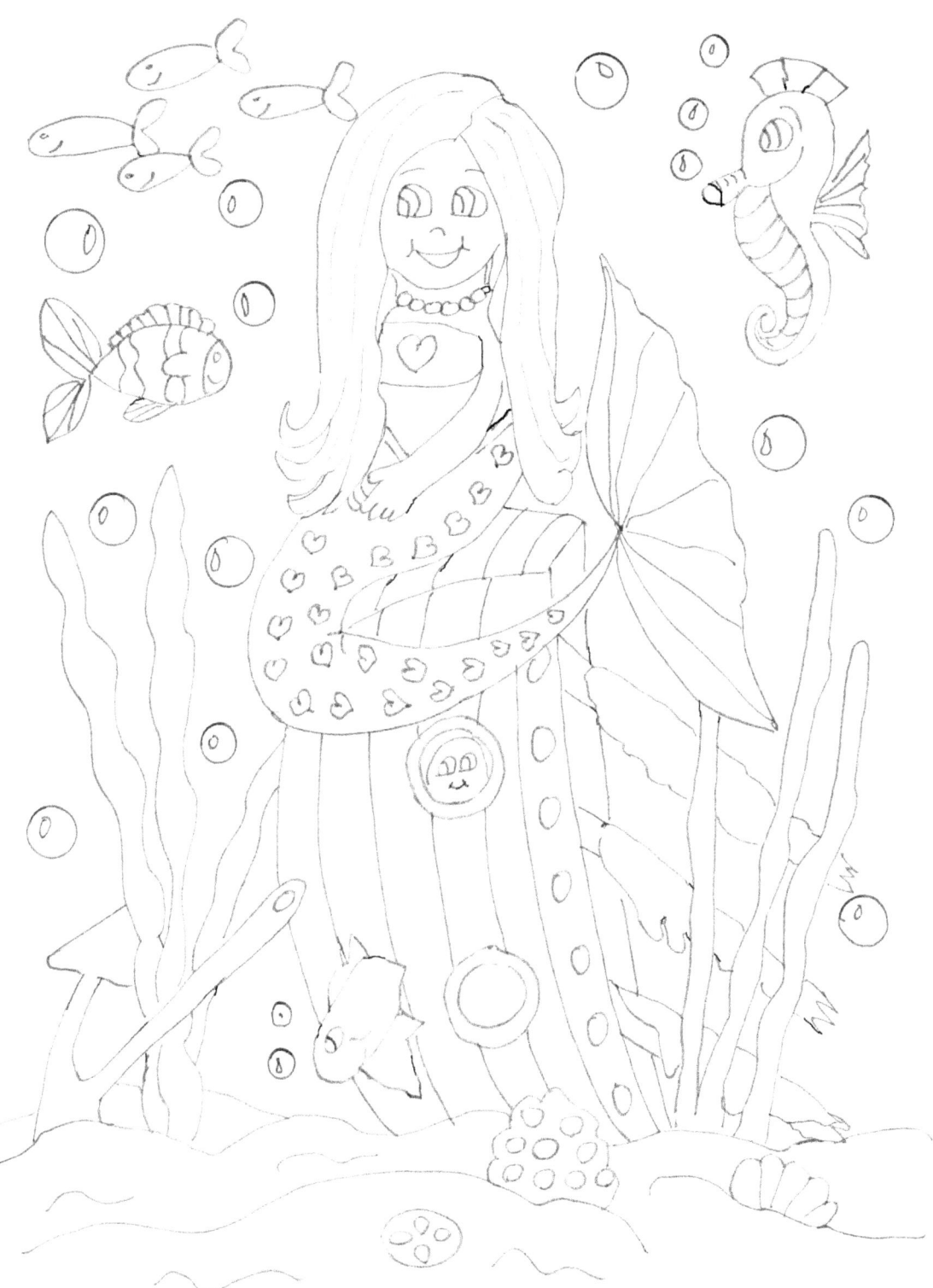

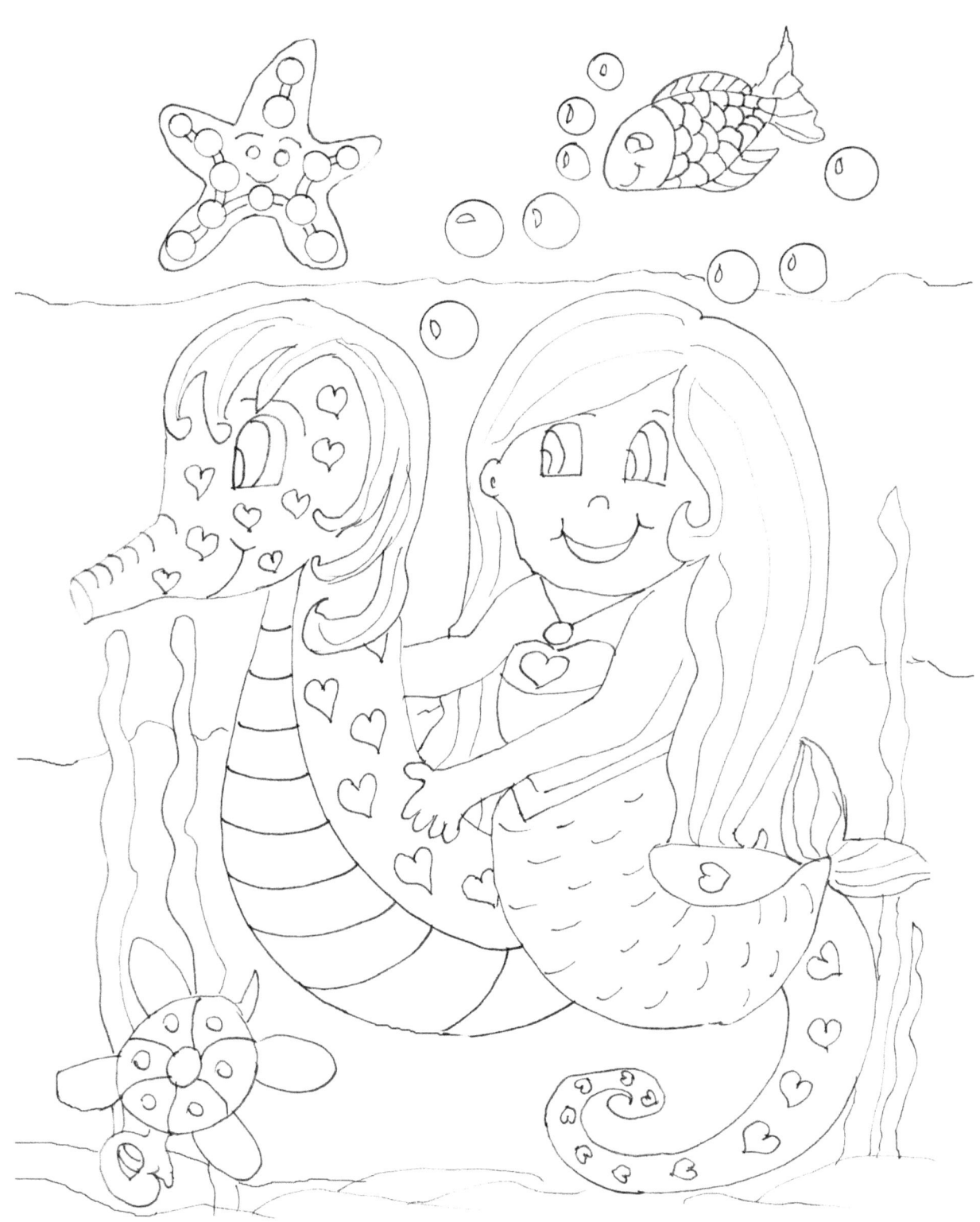

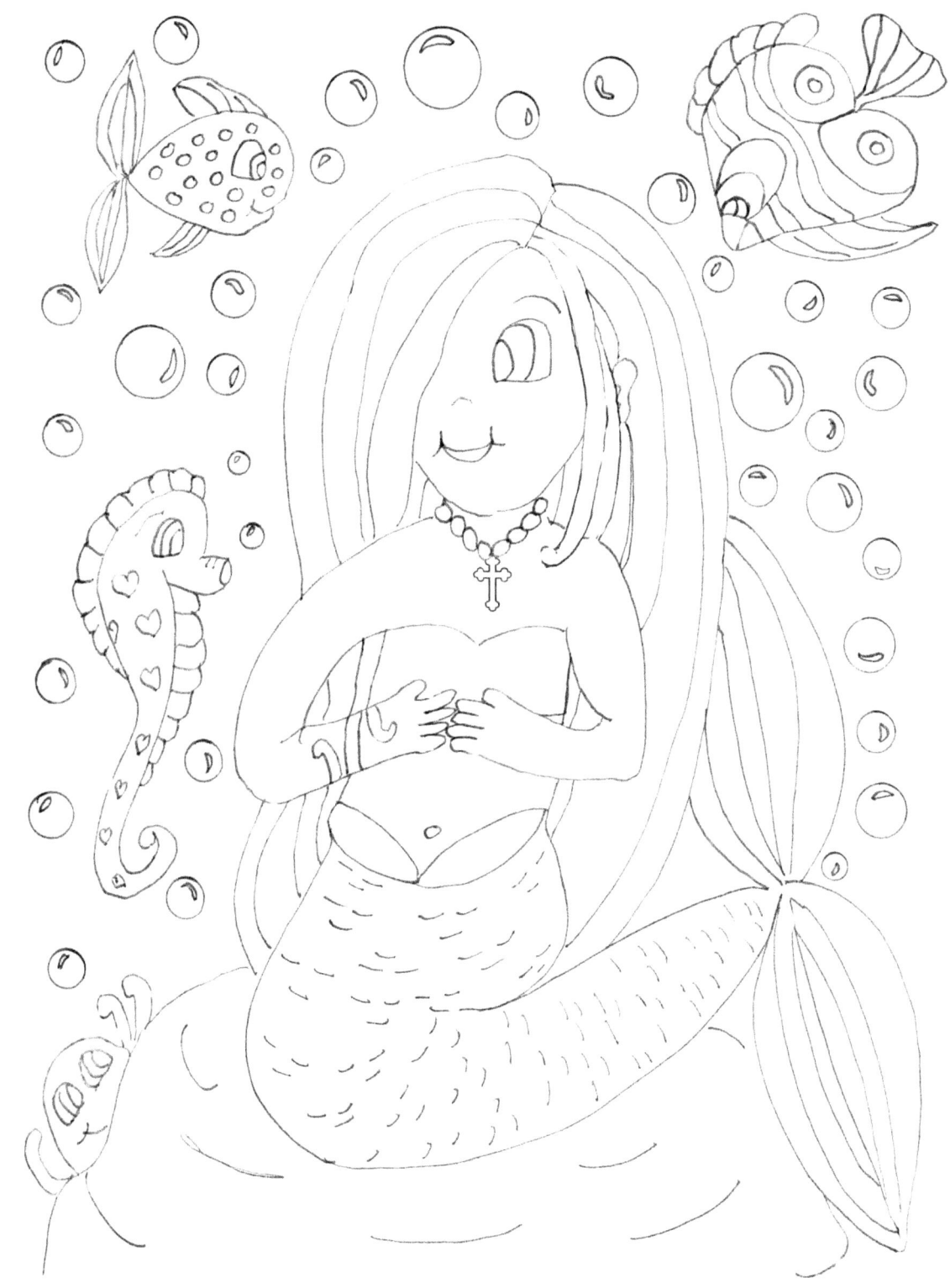

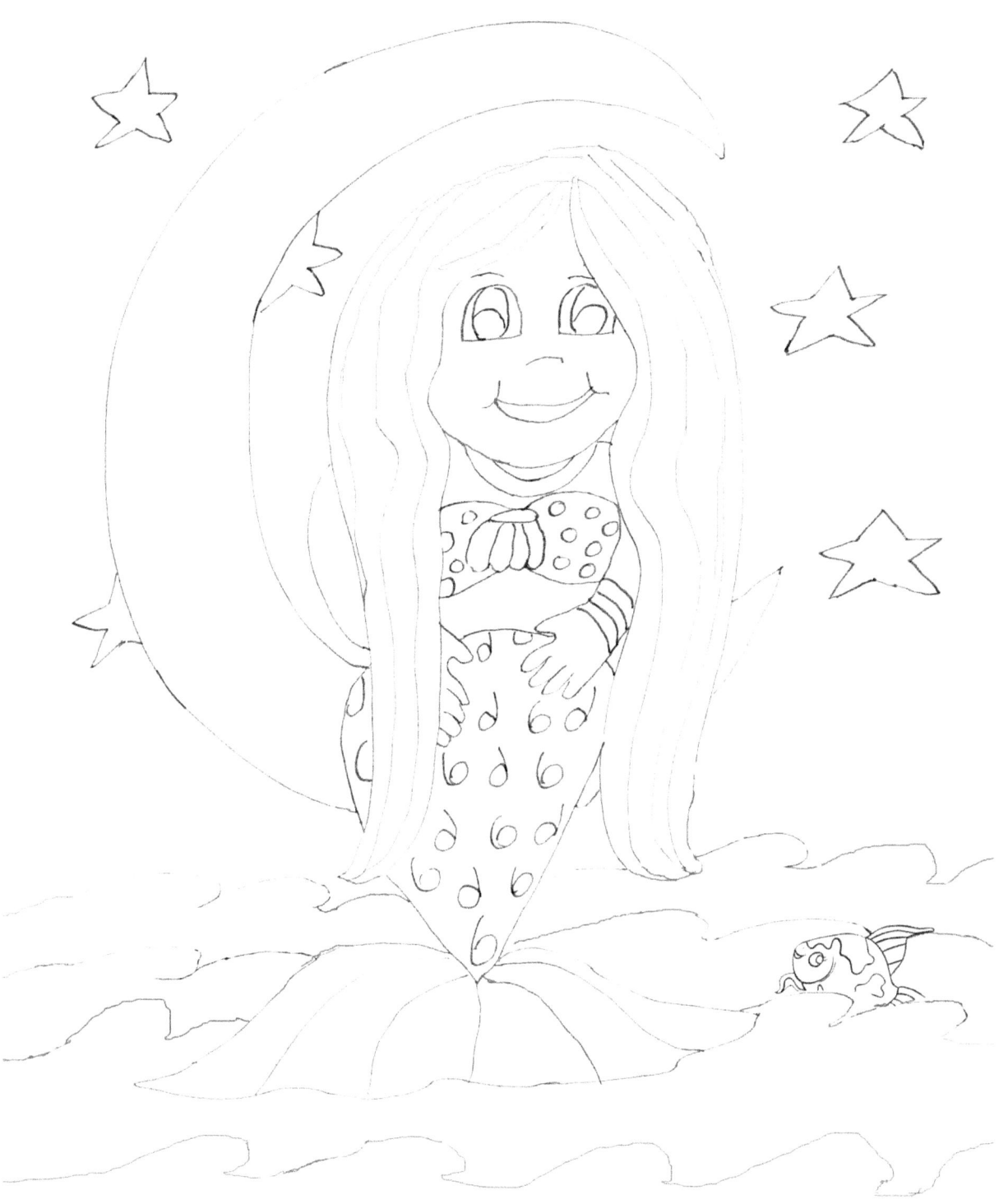

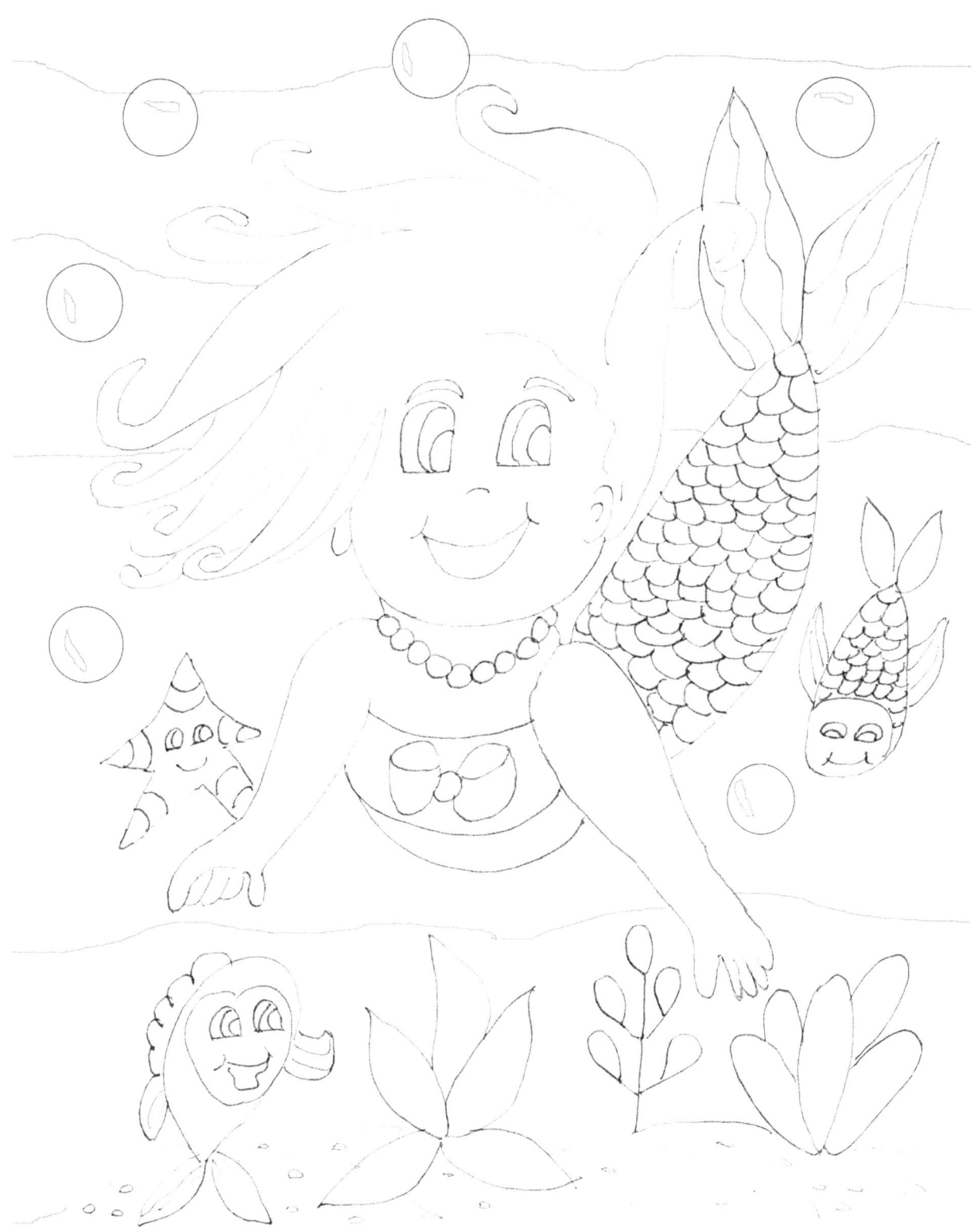

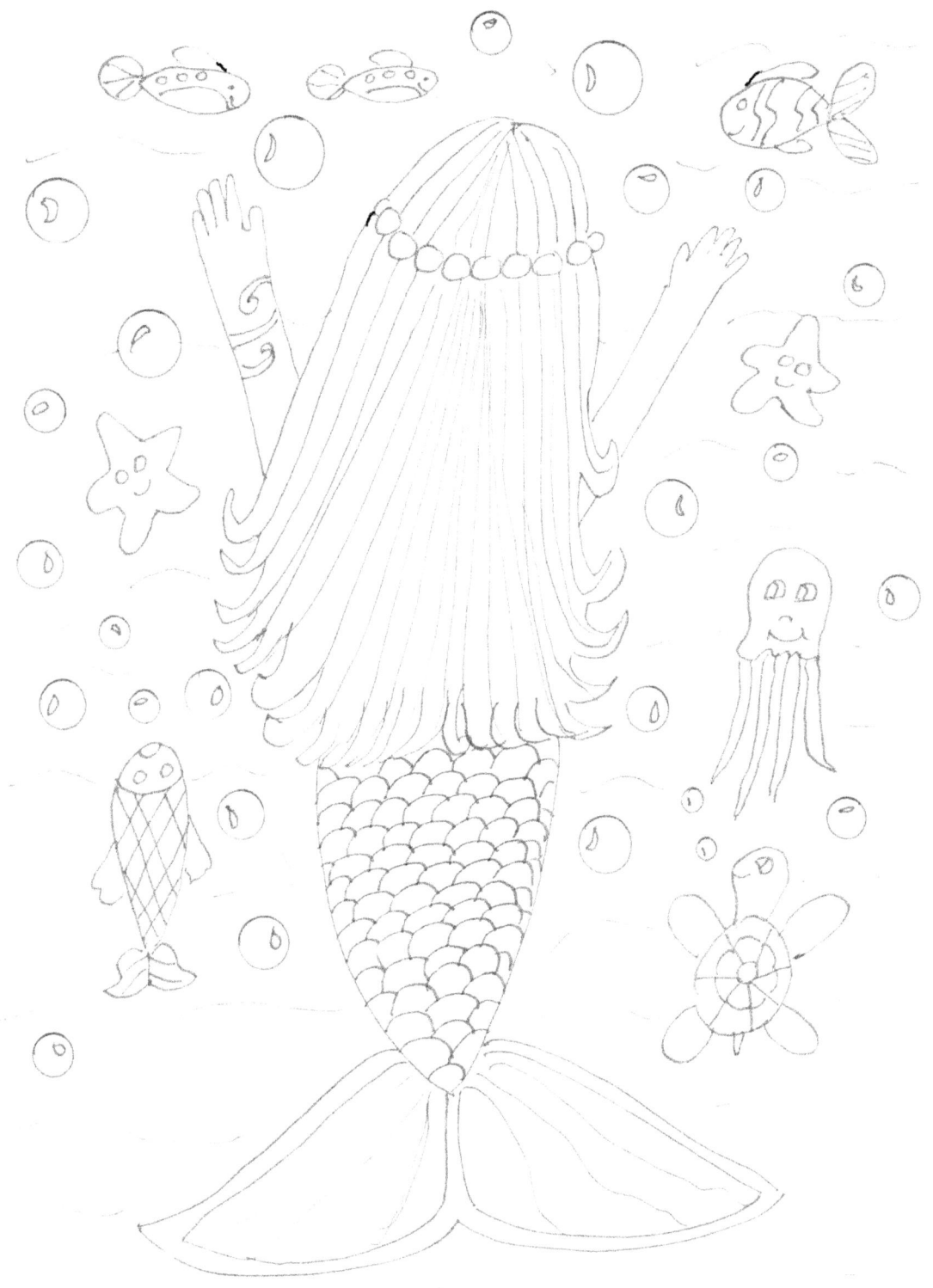

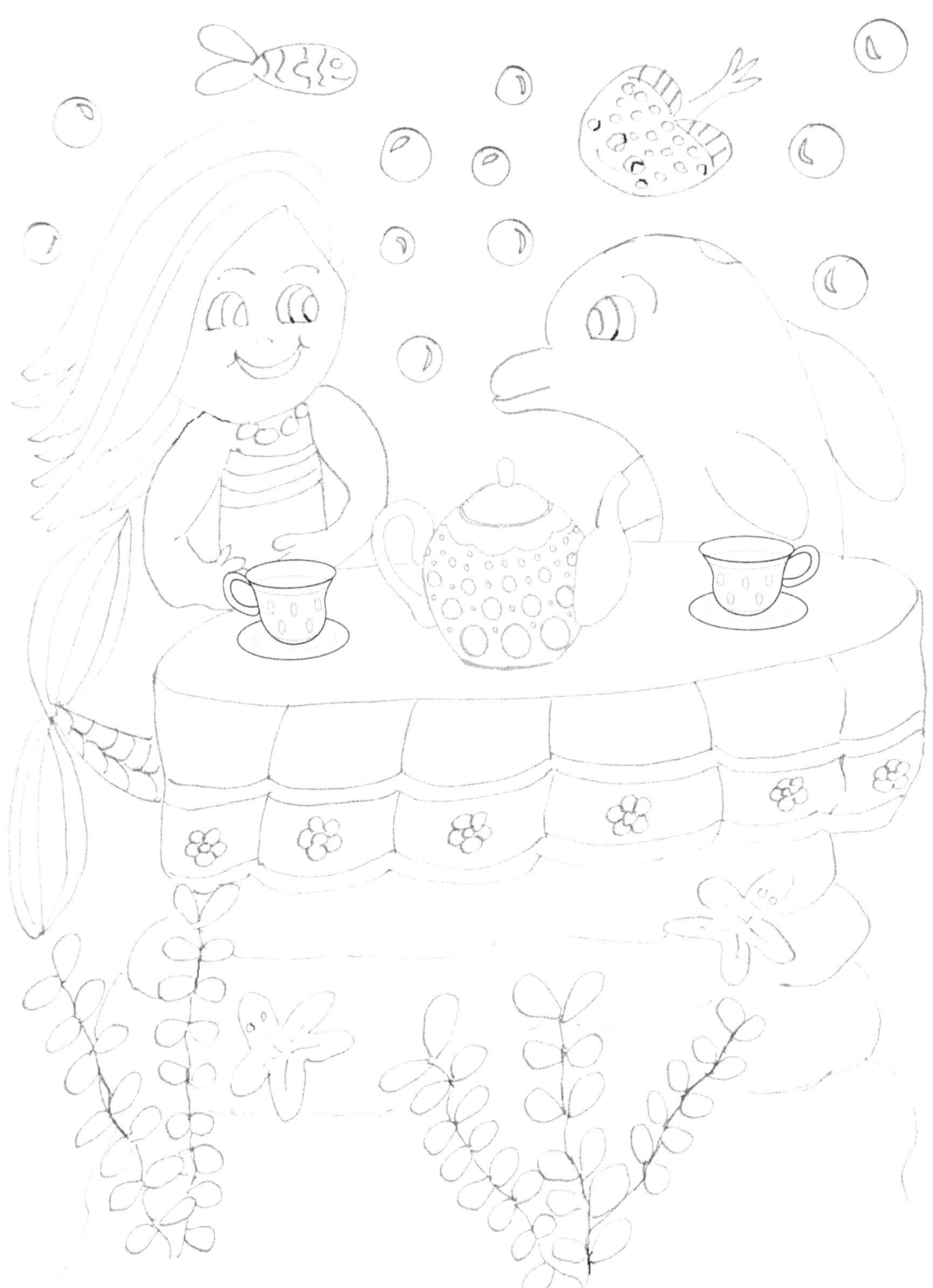

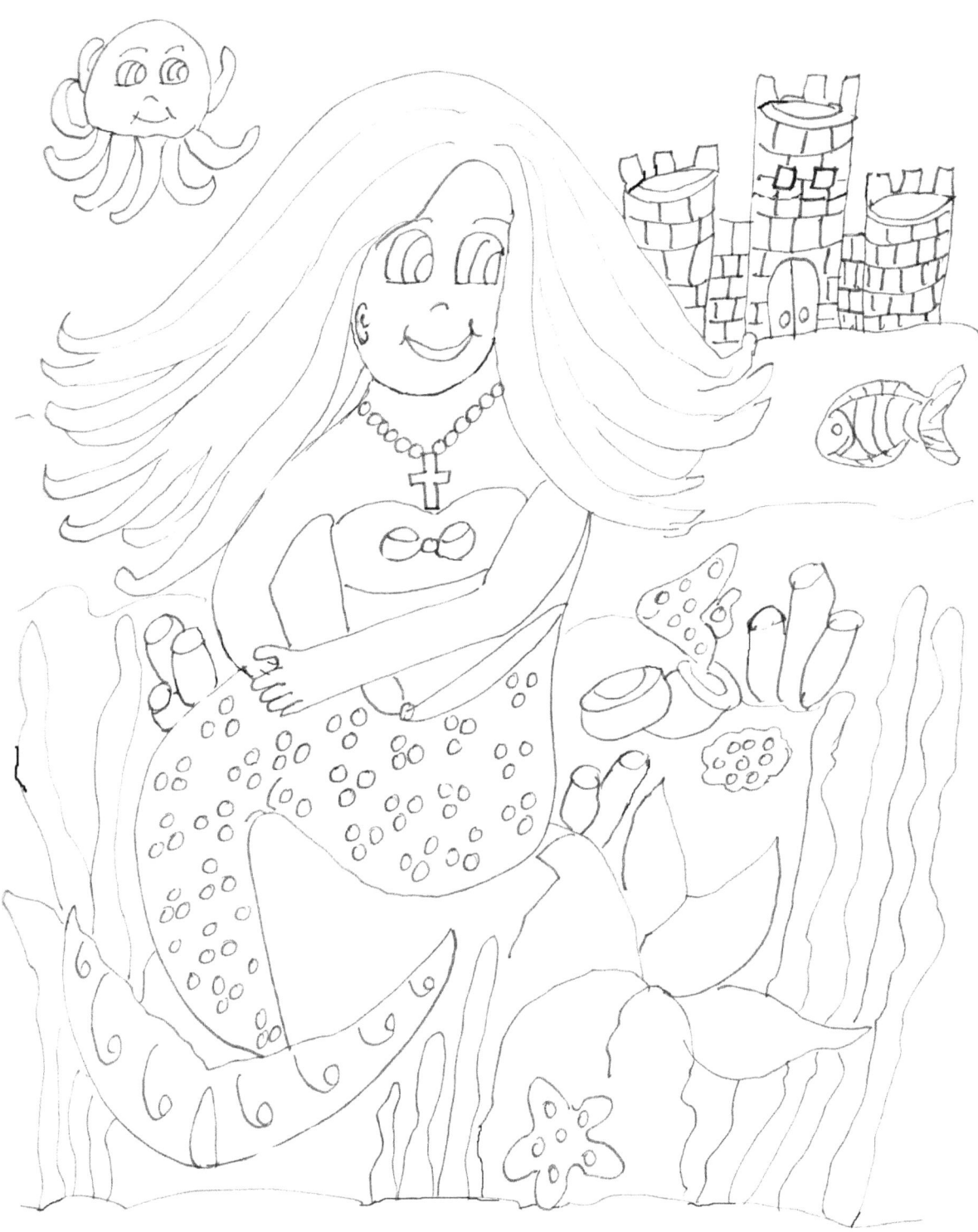

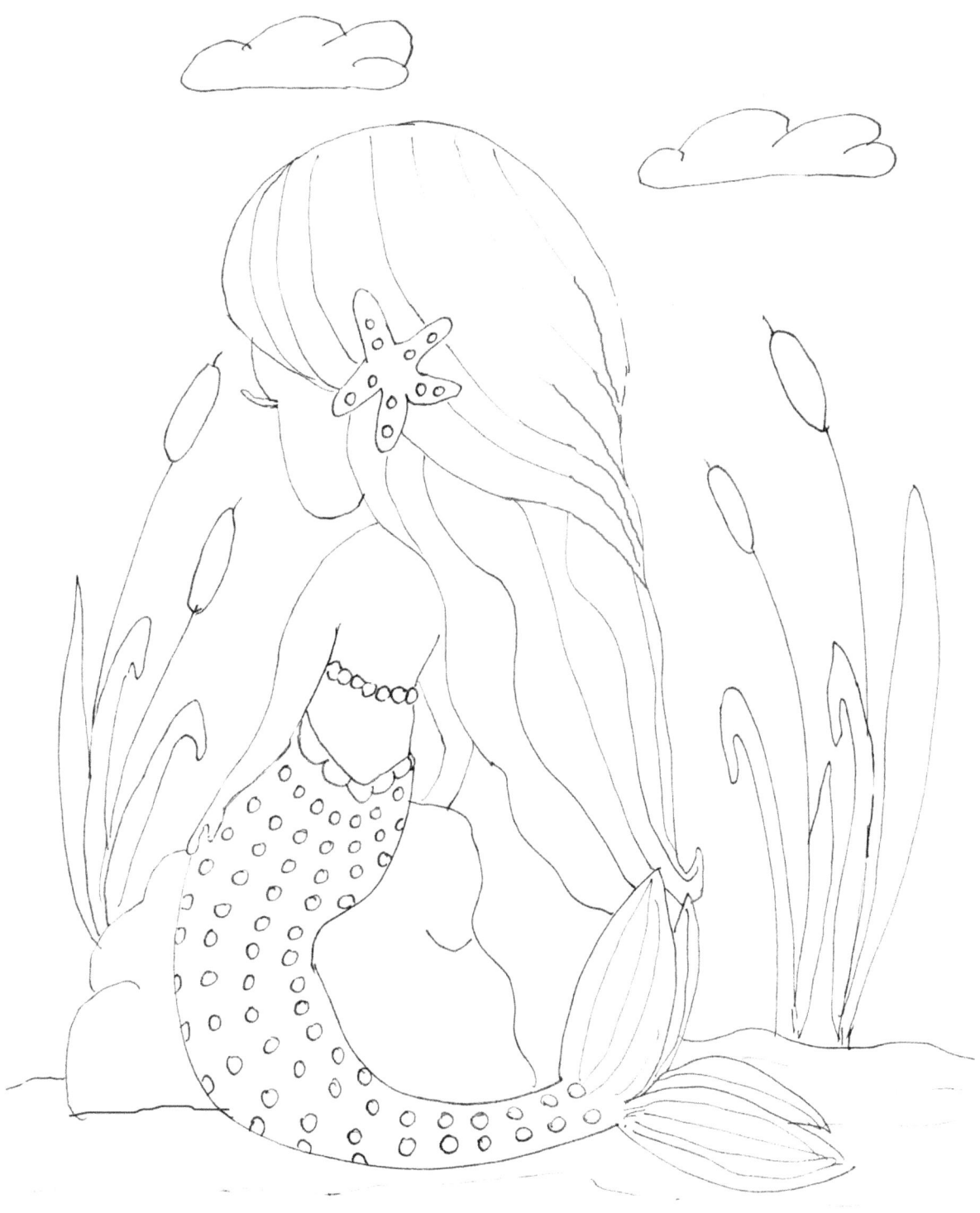

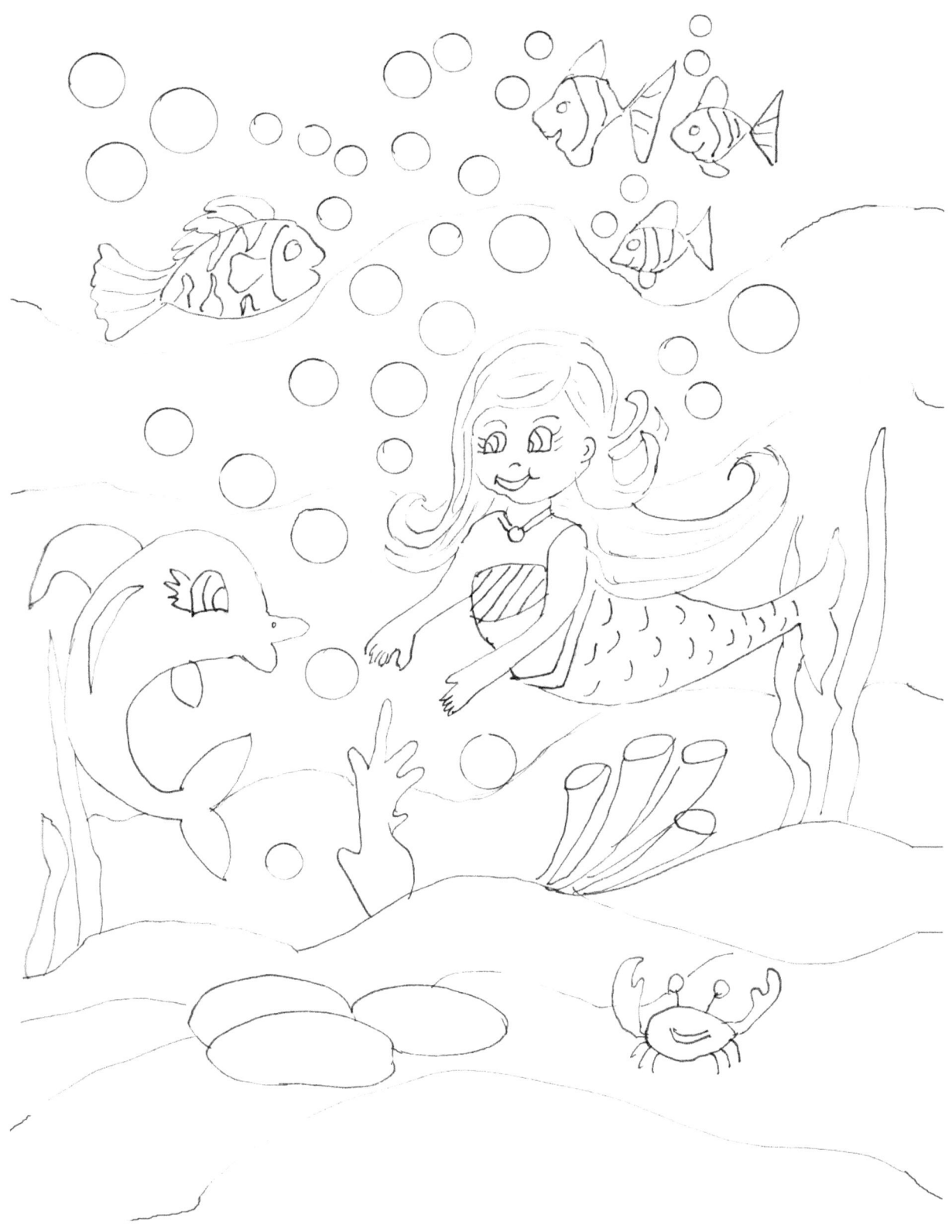

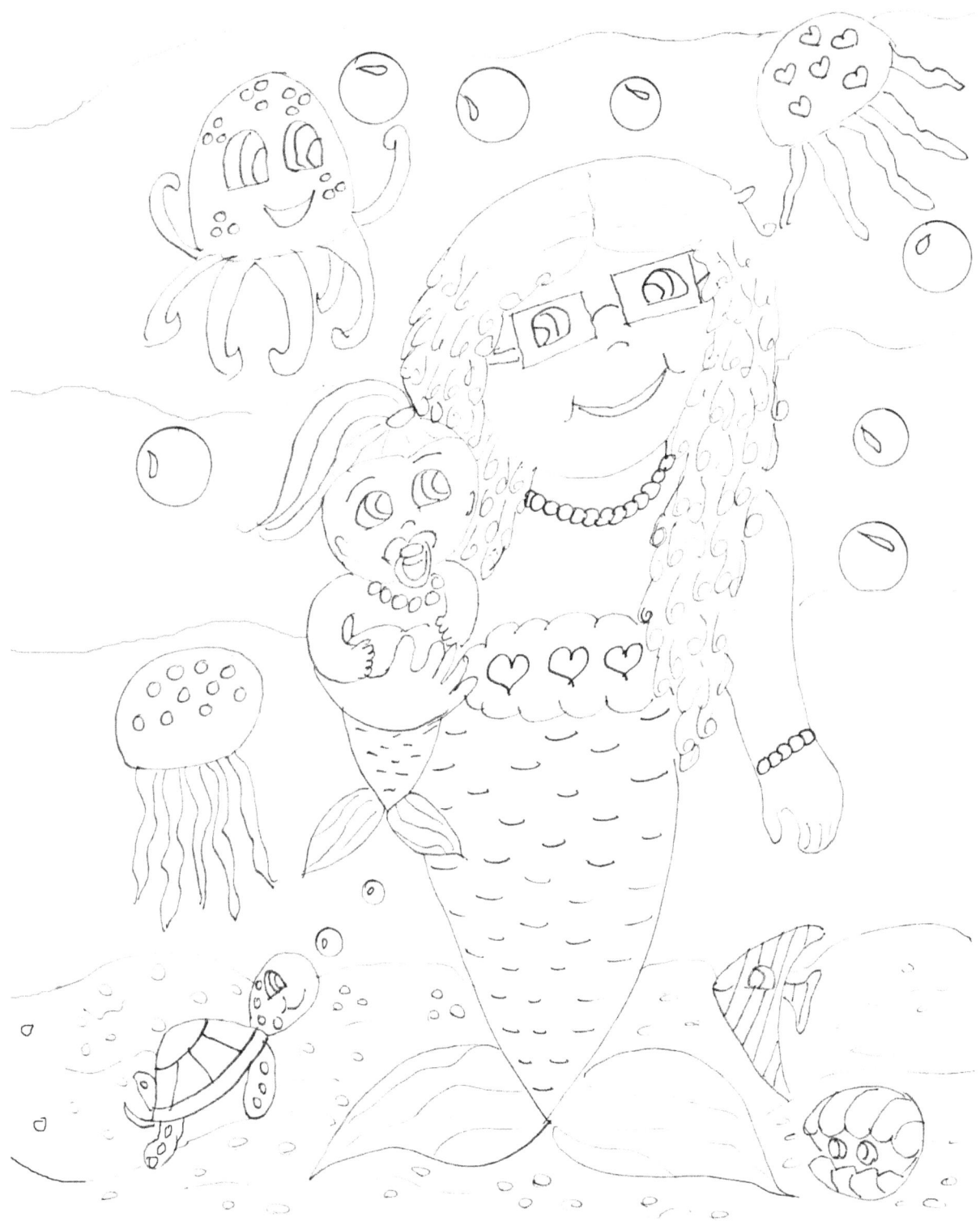

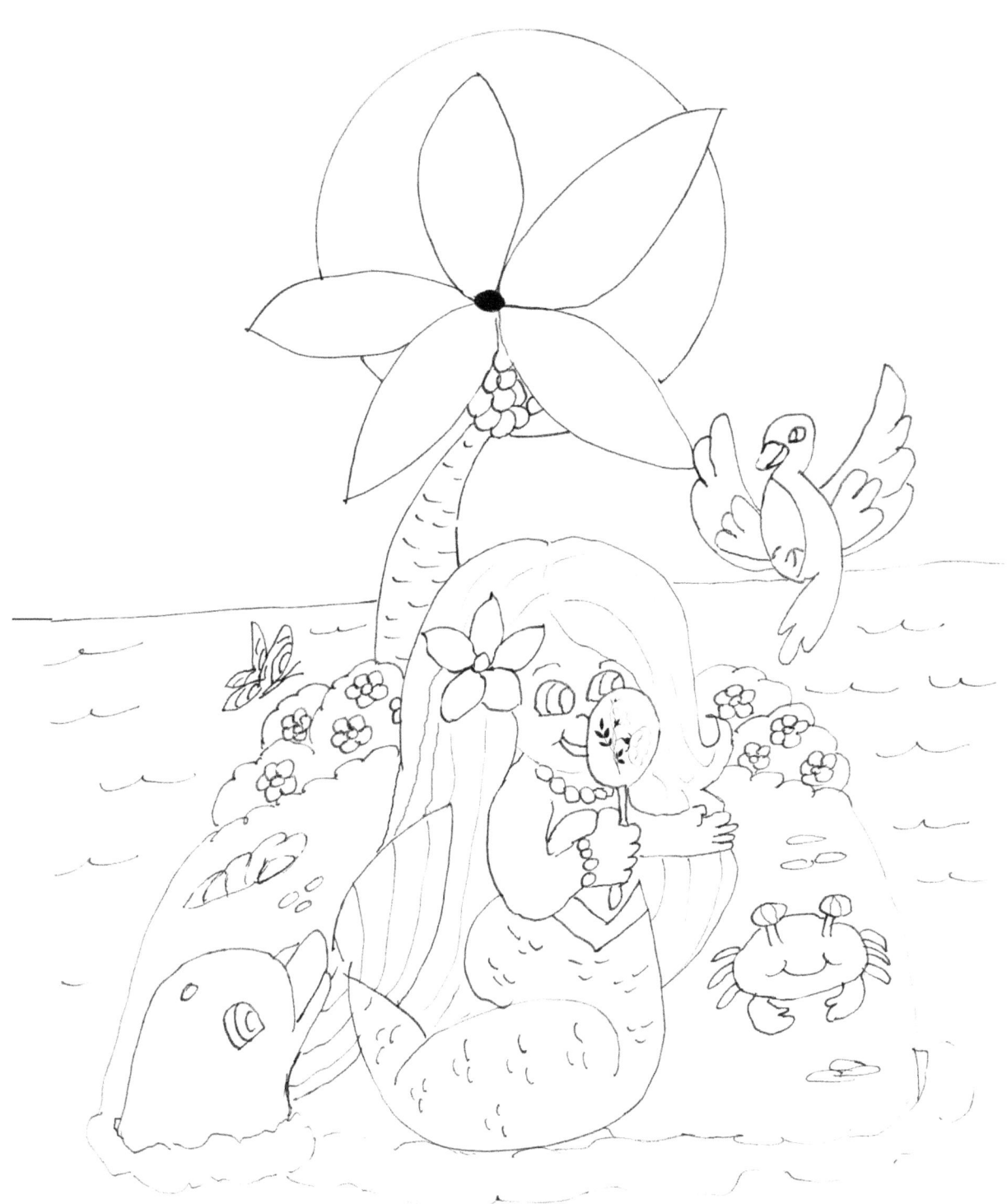

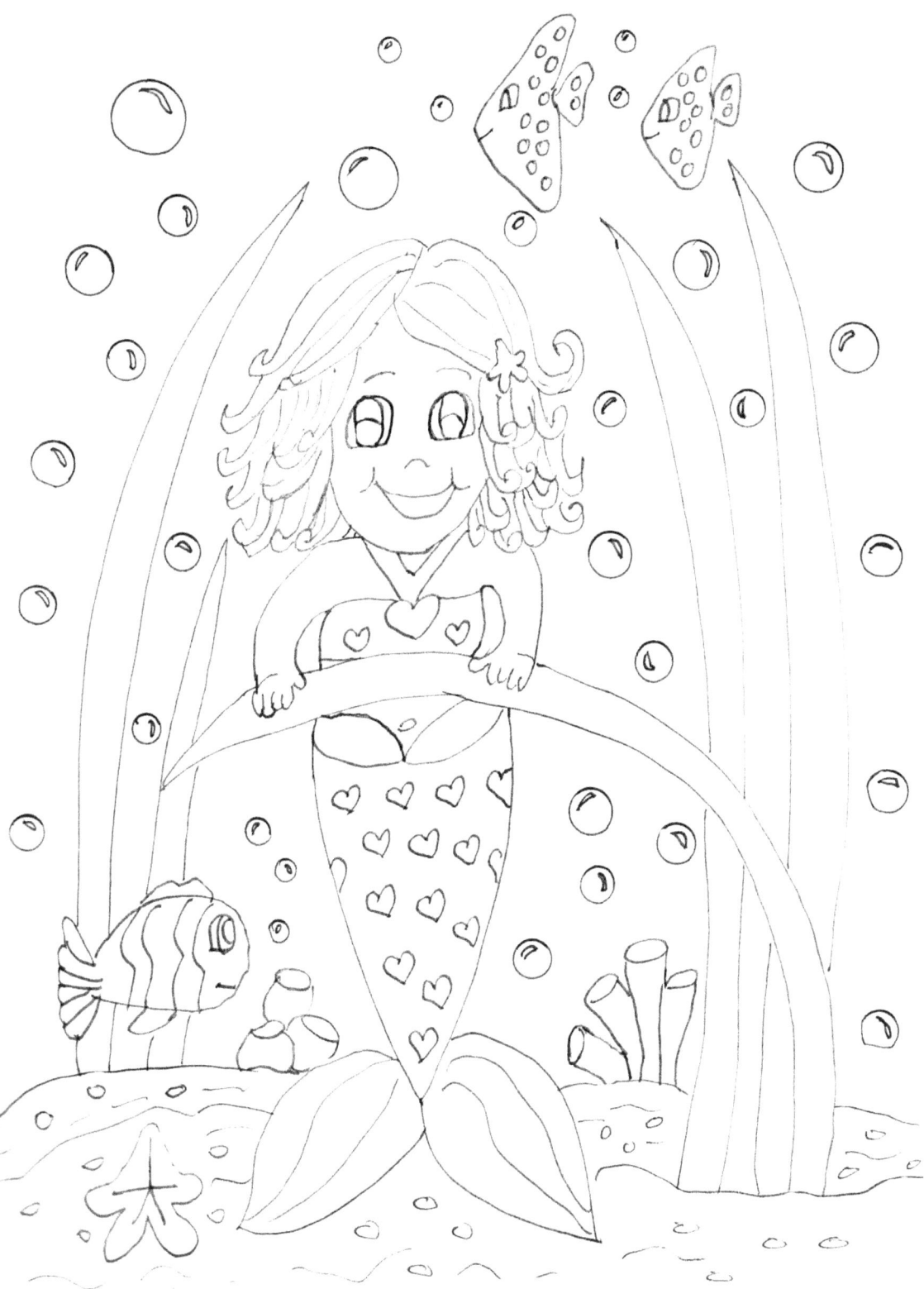

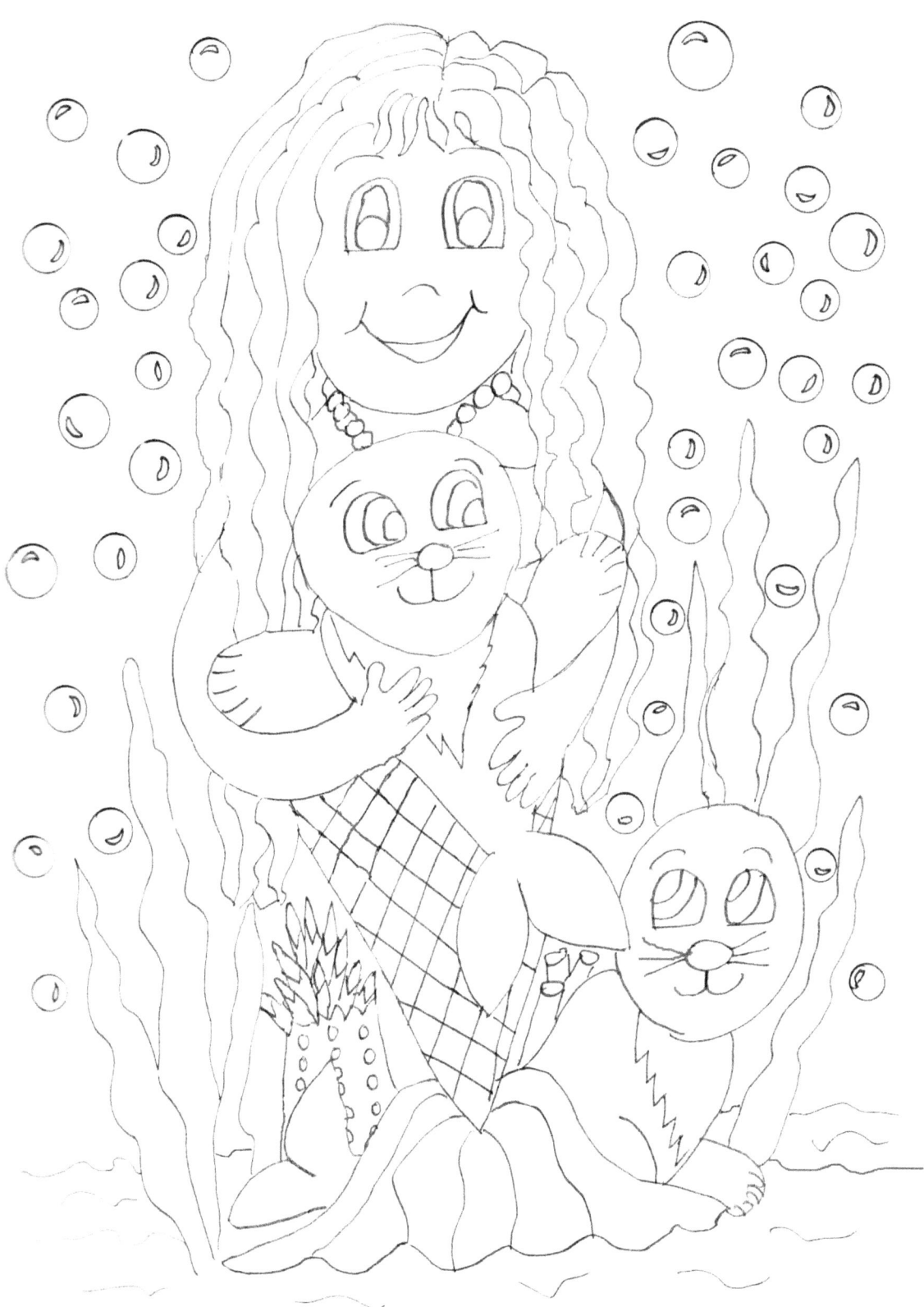

www.ingramcontent.com/pod-product-compliance
Lightning Source LLC
Chambersburg PA
CBHW080544190526
45169CB00007B/2628